T0152970

THE CHICAGO COLORING BOOK

ICONIC LANDMARKS AND HIDDEN GEMS

CHRIS ARNOLD

MIDWAY

AN **AGATE** IMPRINT

CHICAGO

Copyright © 2016 by Chris Arnold

All rights reserved. No part of this book may be reproduced or transmitted in any form or by any means, electronic or mechanical, including photo- copying, recording, or by any information storage and retrieval system, without express written permission from the publisher.

All brand names used in this book are the property or trade names of their respective holders. Agate Publishing, Inc., is not associated with any product or vendor in this book.

Printed in the United States

The Chicago Coloring Book
ISBN-13: 978-1-57284-215-1
ISBN-10: 1-57284-215-6

10 9 8 7 6 5 21 22 23 24 25

Midway is an imprint of Agate Publishing. Agate books are available in bulk at discount prices.

agatepublishing.com

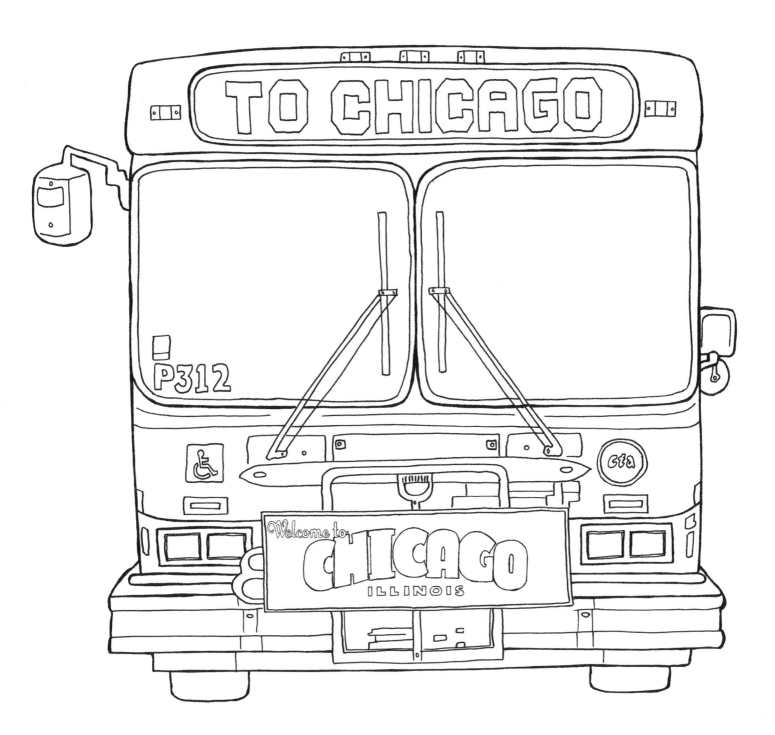

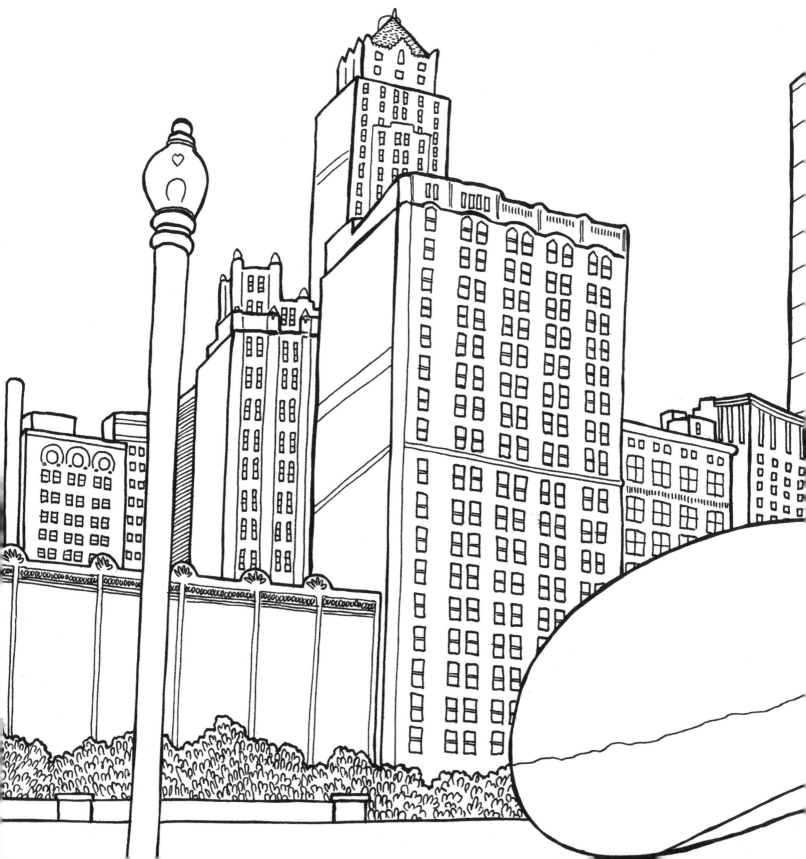

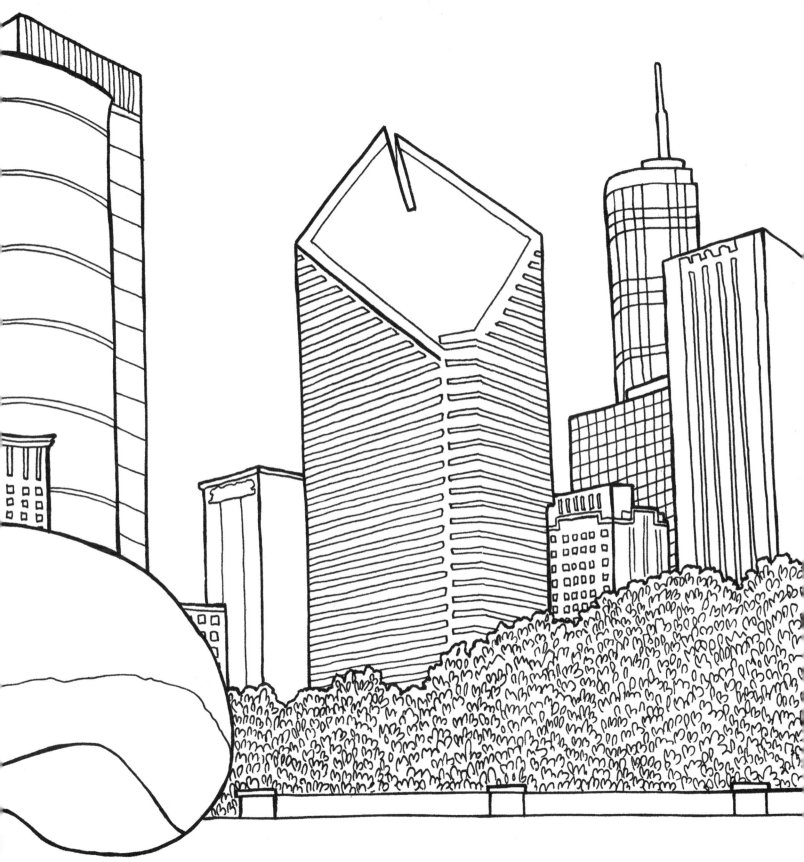

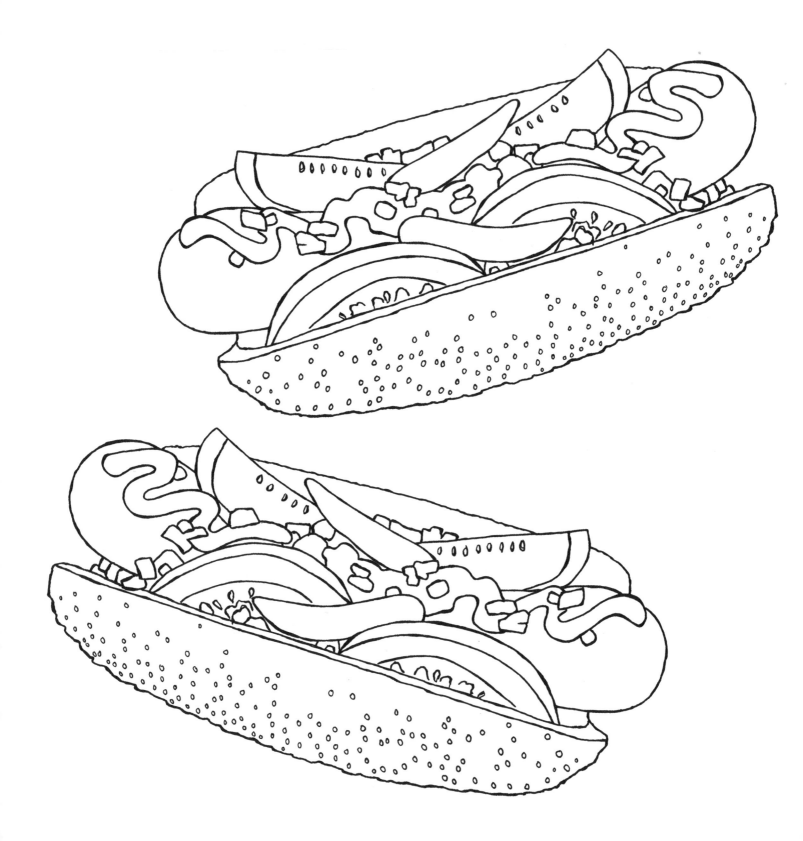

ADS			
...KEN	7	1	9
...SAR	7	1	9
	3	6	9

...RDERS					
...d	1 79	LG	1 9 9		
...s					
...d	2 5 4	LG	2 7 4		
...m	2 2 5	LG	3 4 5		
...STICKS	3 9 9				
...OOMS	3 1 9				
	1 3 9				
	3 0 9				
...m	3 09	LG	4 1 9		

HOT DOGS & POLISH SAUSAGE			
HOT DOG	2	6	9
DOUBLE HOT DOG	4	4	9
JUMBO CHAR DOG	4	4	9
CORN DOG	2	6	9
POLISH SAUSAGE	4	0	9

SANDWICHES			
ITALIAN BEEF	5	8	9
ITALIAN SAUSAGE	4	0	9
BEEF & SAUSAGE COMBO	6	6	9
GYROS	5	8	9
GYROS PLATE	8	1	9
PHILLY CHEESE STEAK	5	9	9
RIBEYE STEAK SANDWICH	6	6	9
FISH SANDWICH w/CHEESE	3	9	9

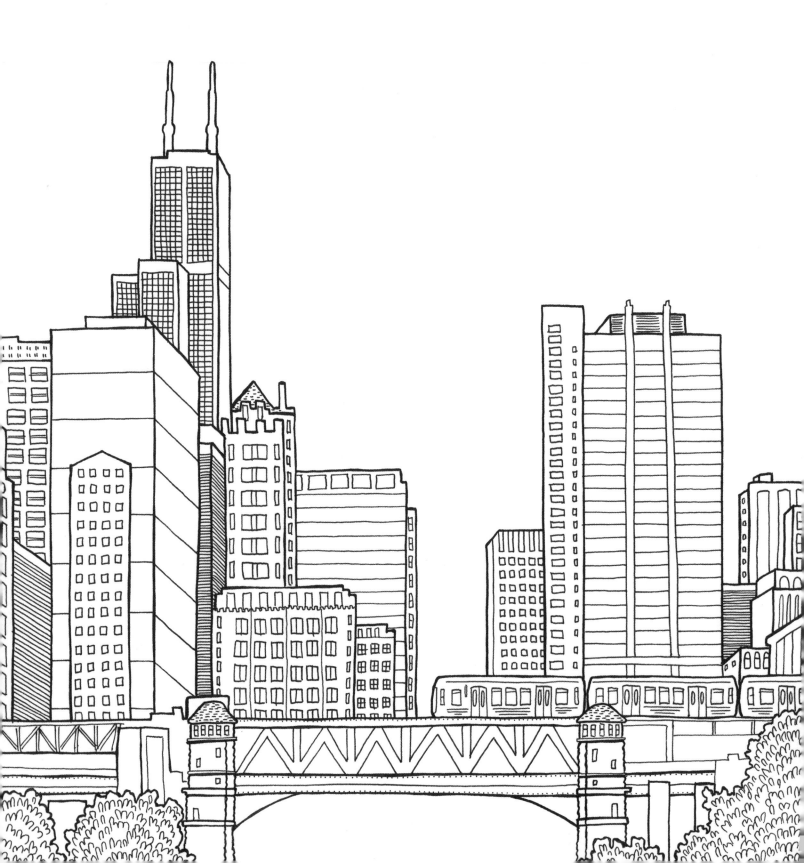

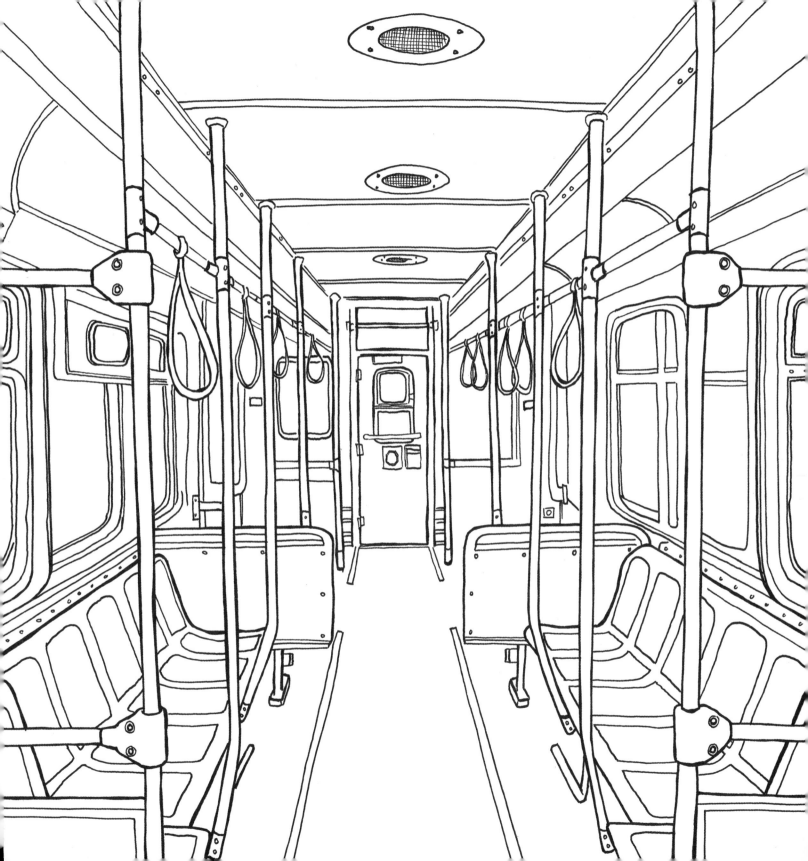

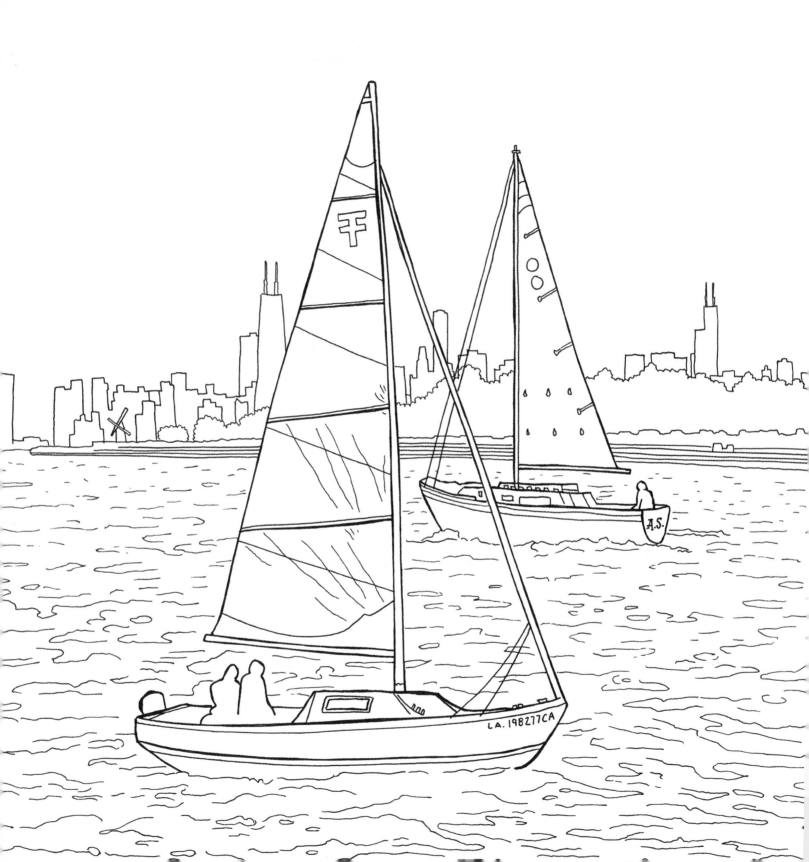

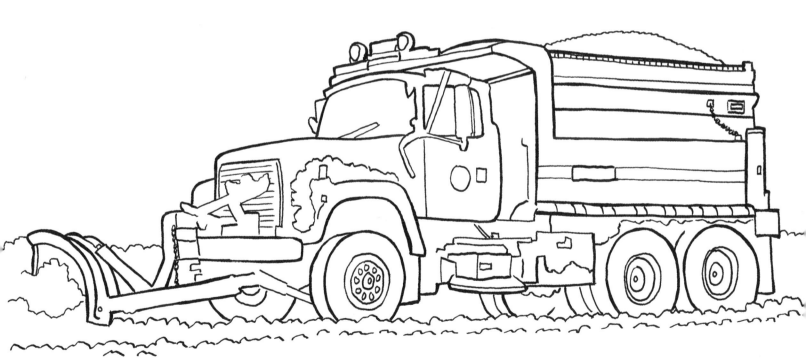

- °N CICERO AV° 800 W
- °S HALSTED ST° 400 W
- N PULASKI RD
- N CLARK ST
- HONORARY THE MAGNIFICENT MILE
- W DEVON AV
- Chicago 2001 N Michigan AV
- S WESTERN AV
- DR. MARTIN LUTHER KING JR DR.
- RANDOLPH St.
- State St.

N RUSH ST

Chicago 2001 **E Chicago AV**

W CERMAK RD

W MAXWELL ST

41 NORTH
Lake Shore Dr
↘ NO TRUCKS ↘

↖ TO LOWER WACKER DRIVE

W MADISON ST

N LINCOLN AV

Orange Line ✈ ⬆

 Red Line
Subway

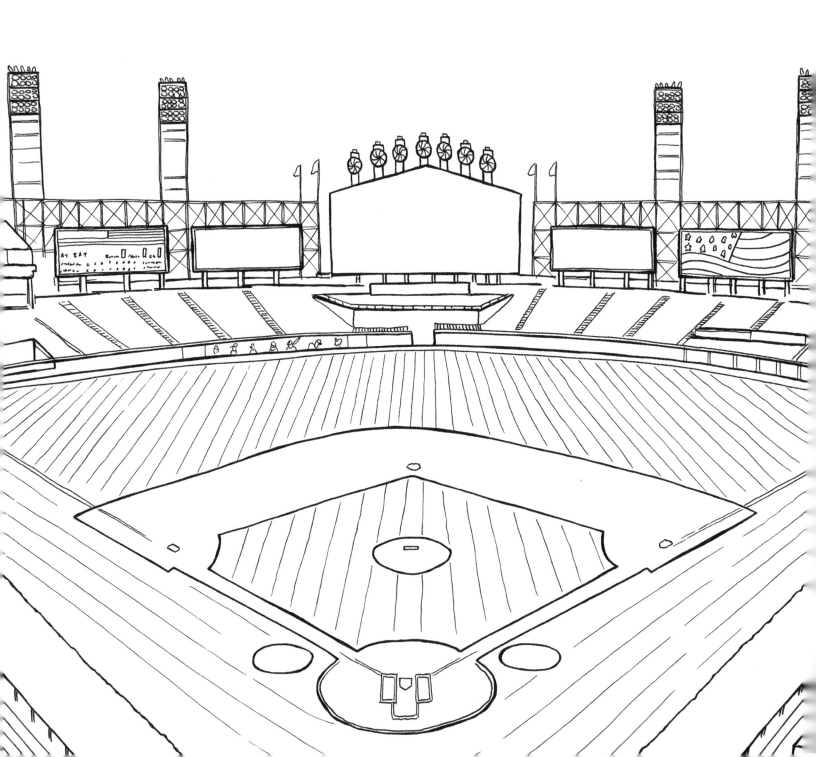

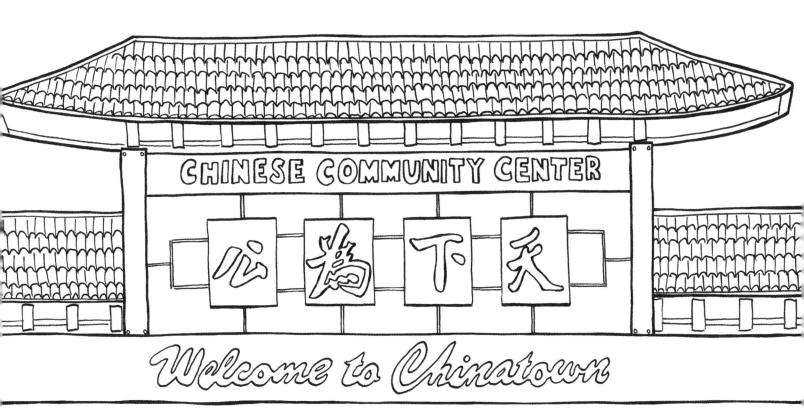

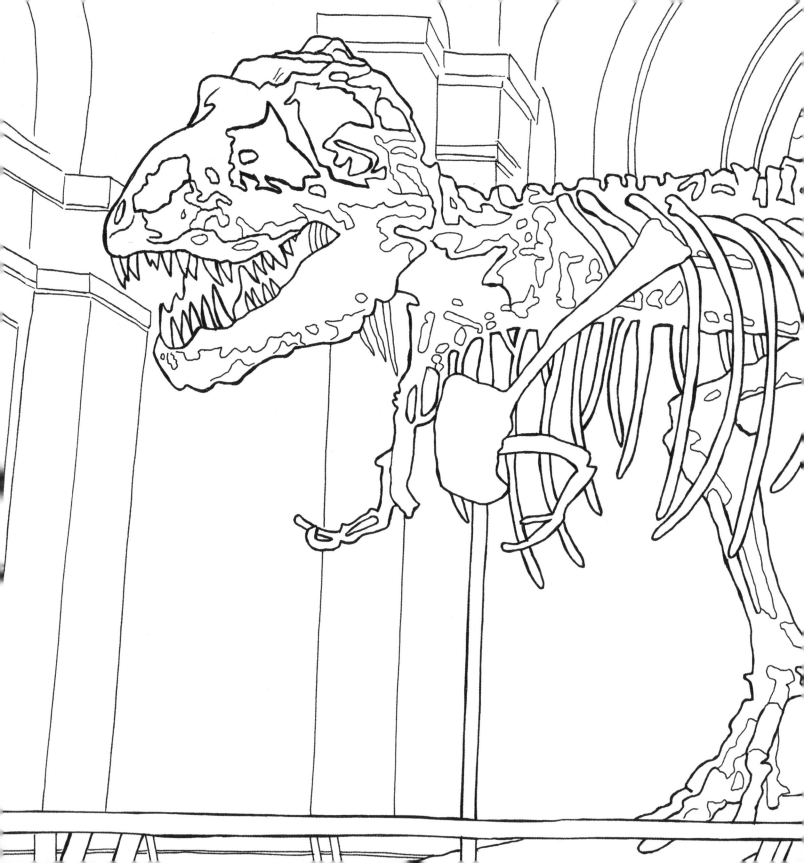

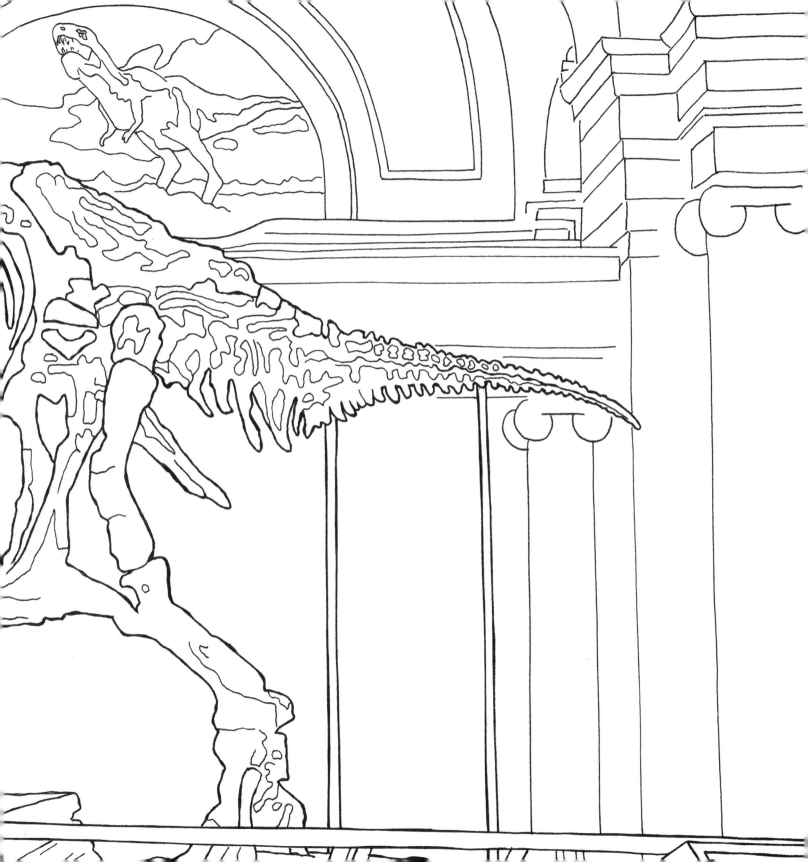

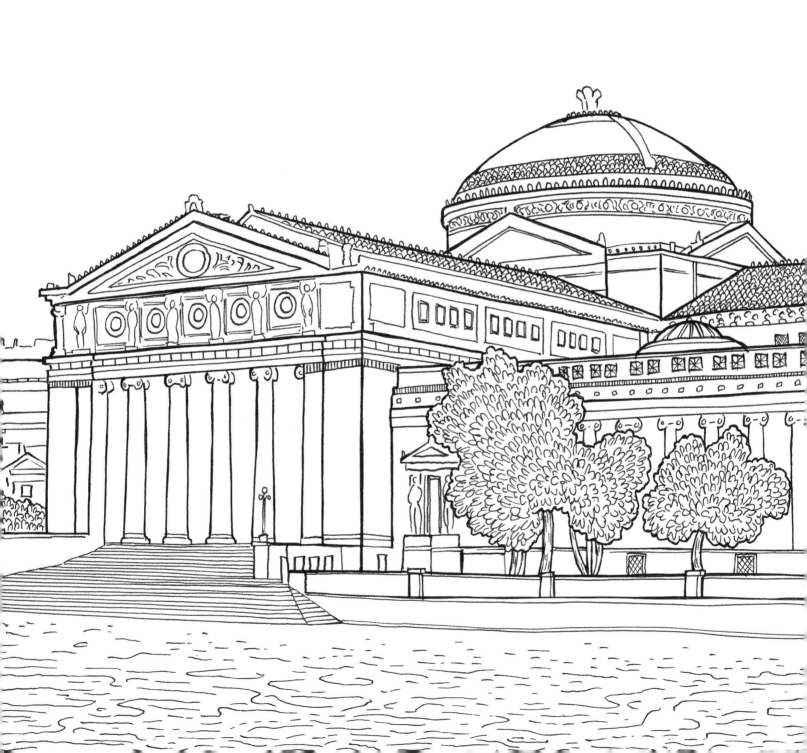

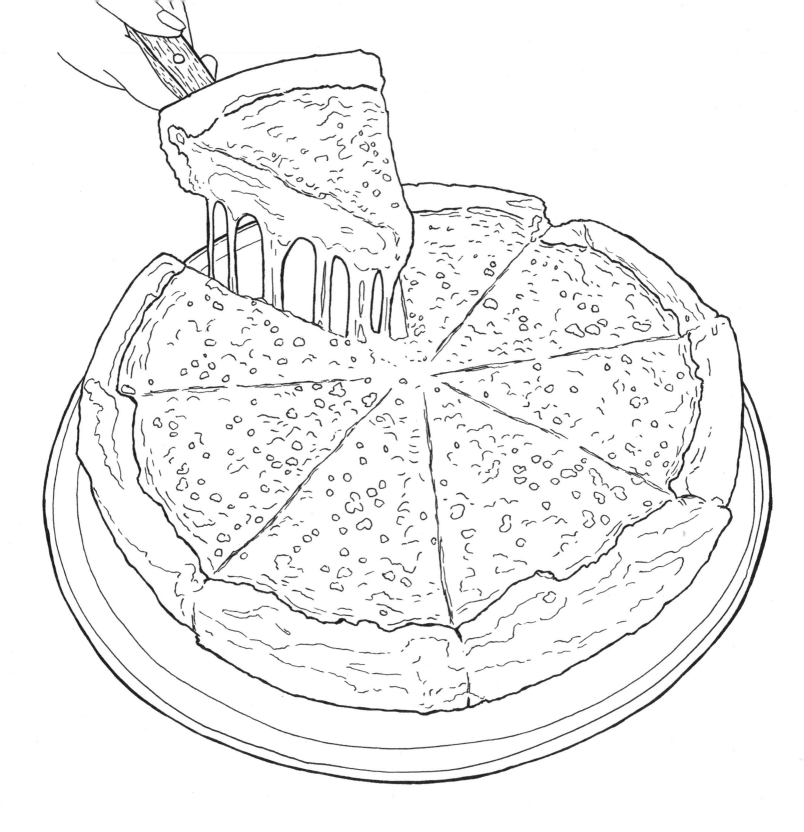

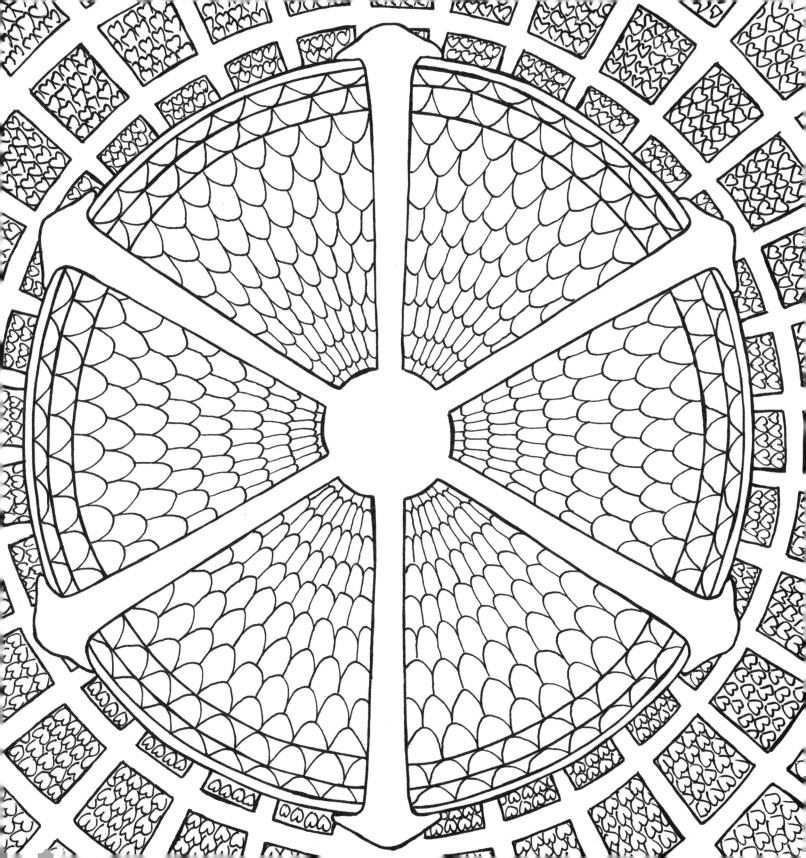

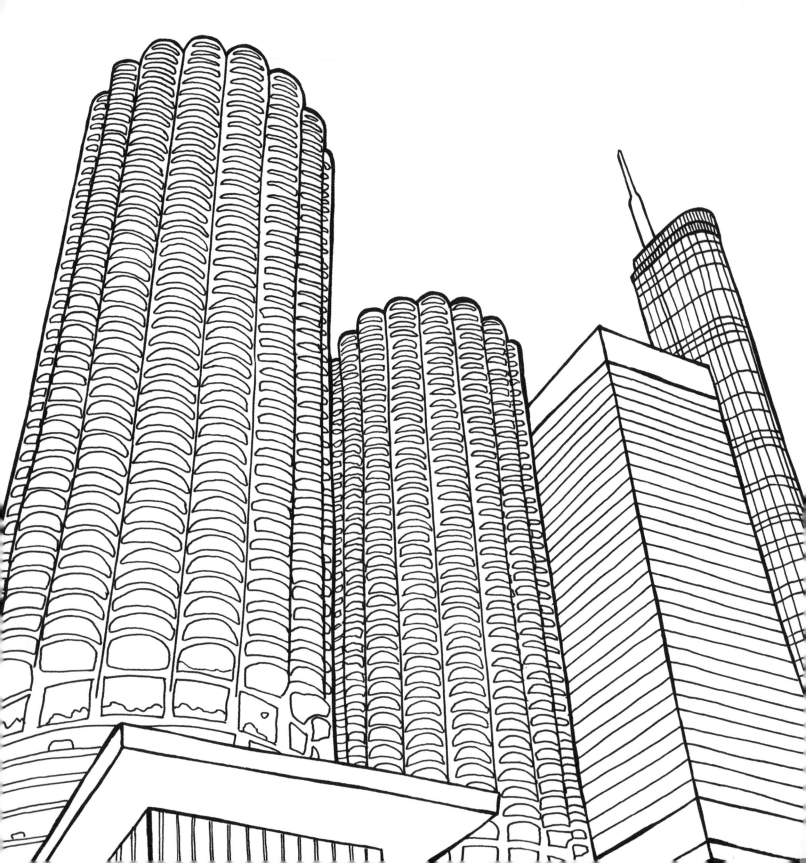

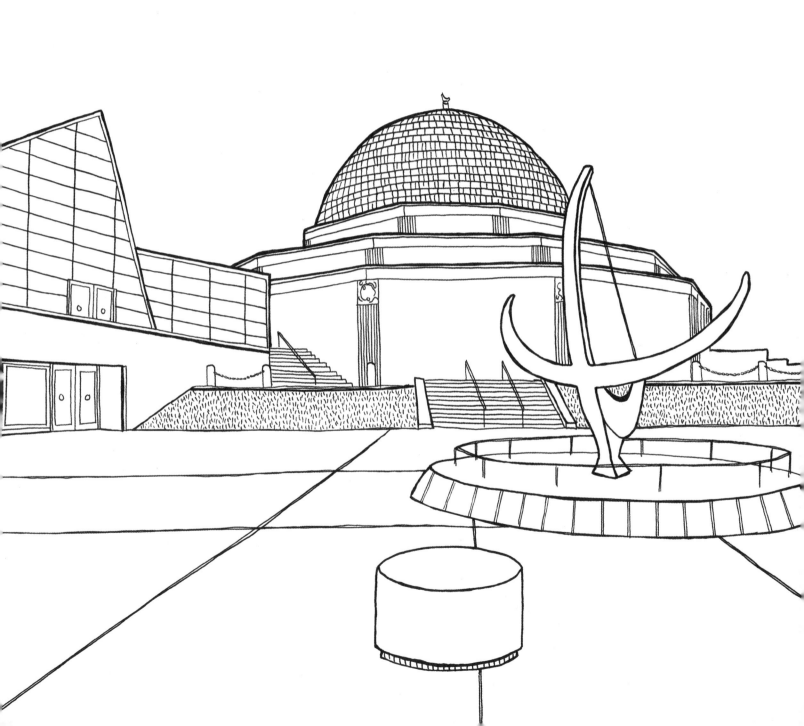

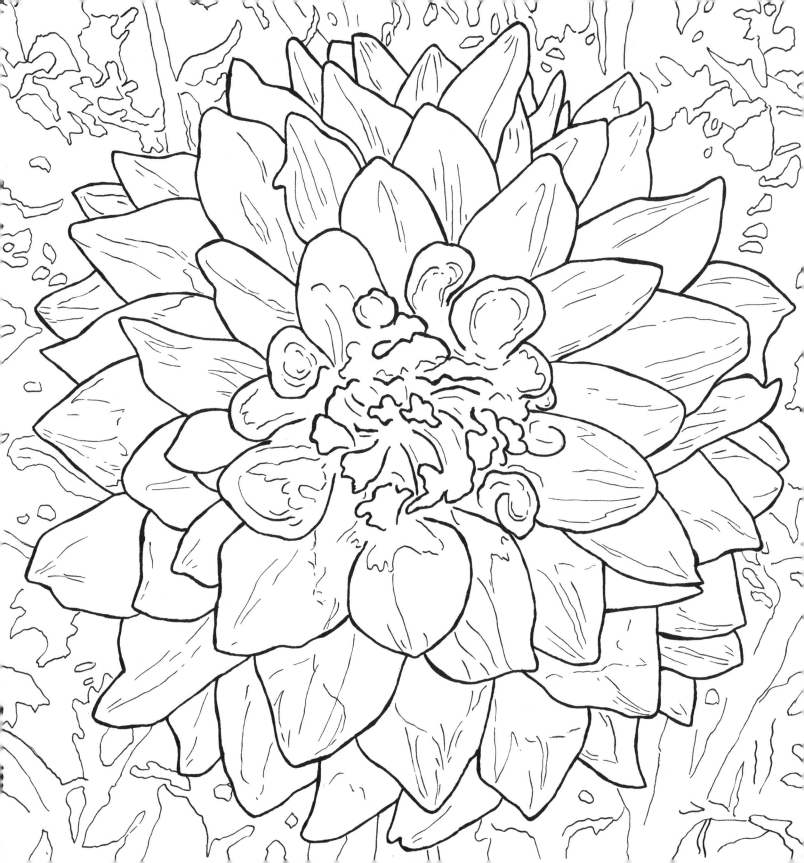

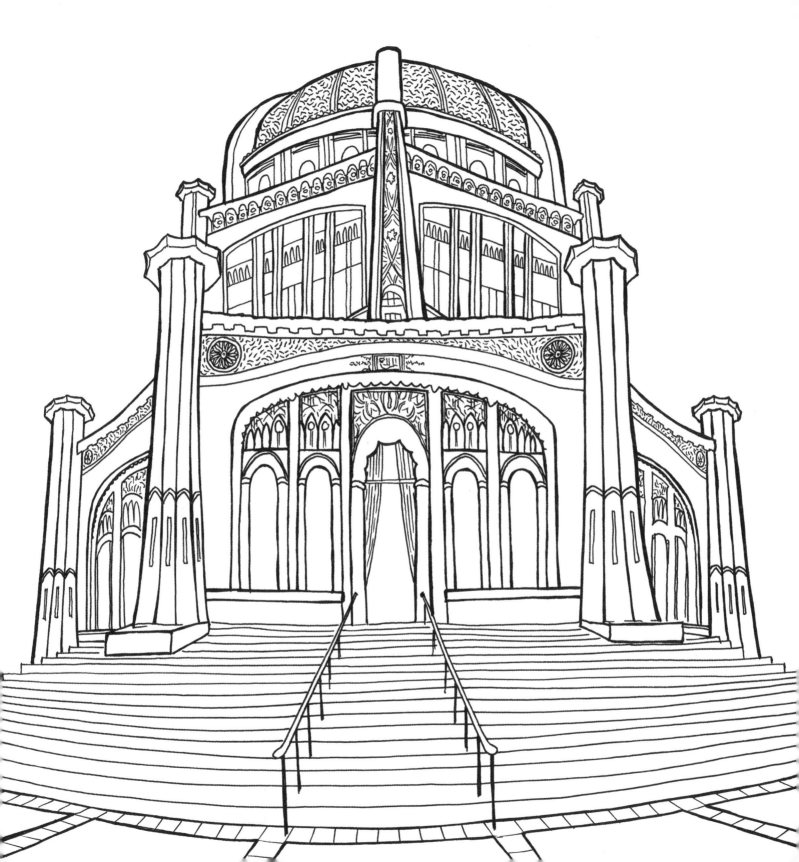

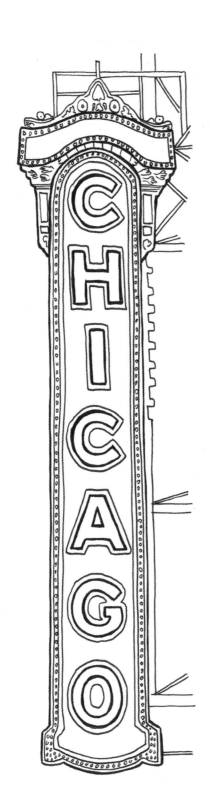
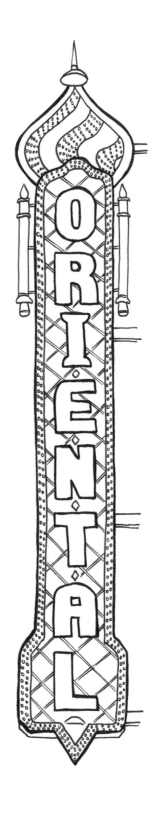

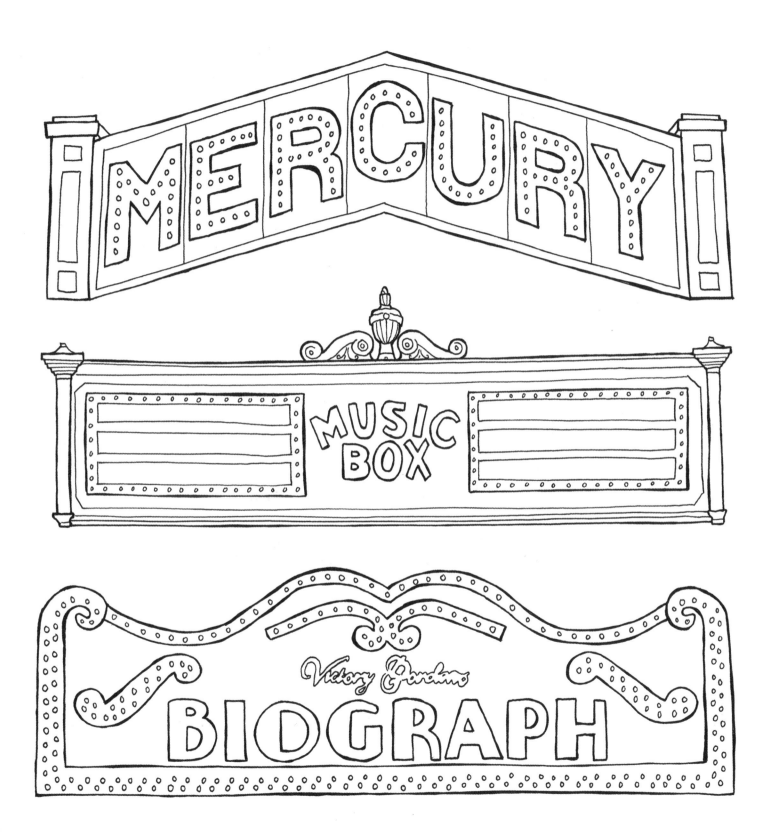

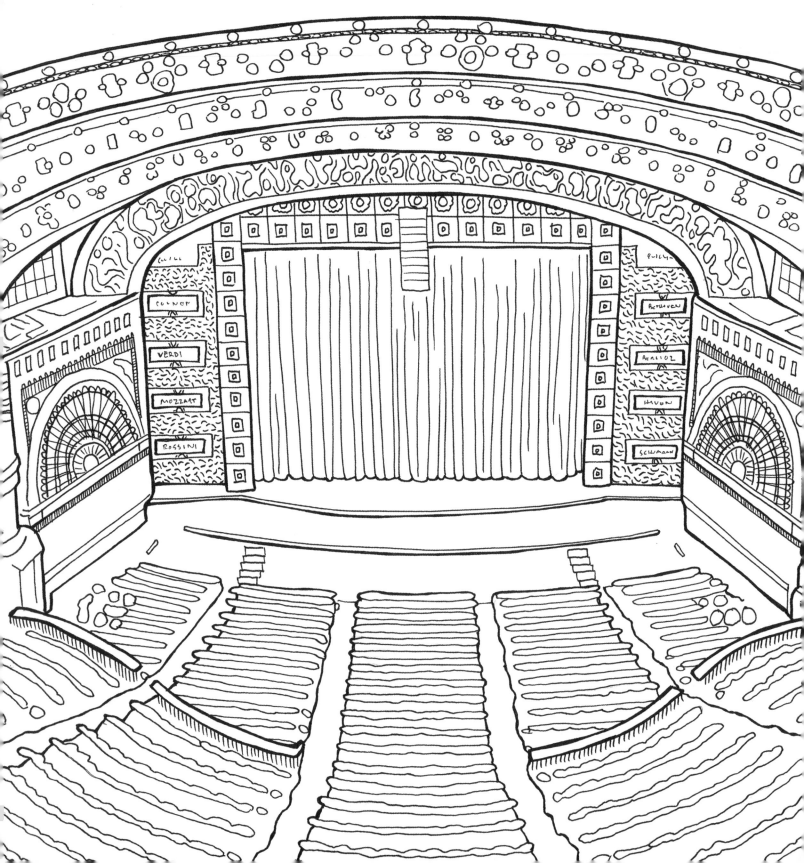

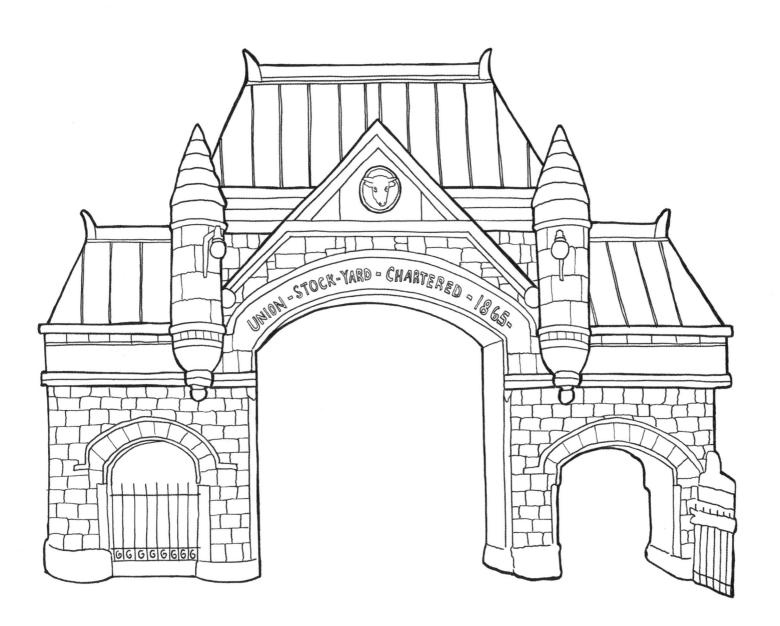

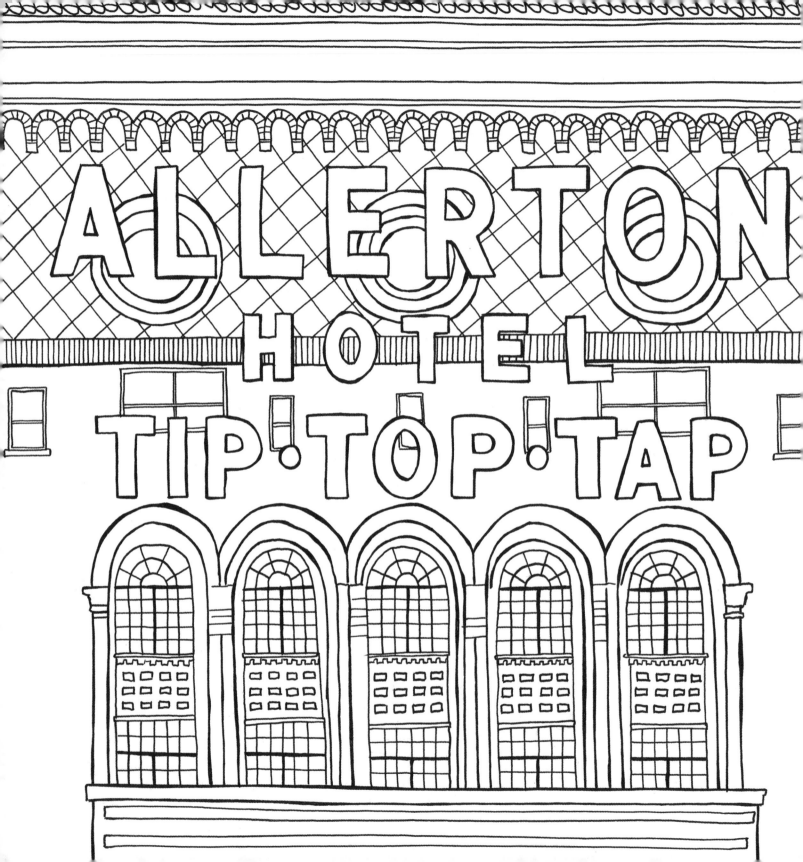

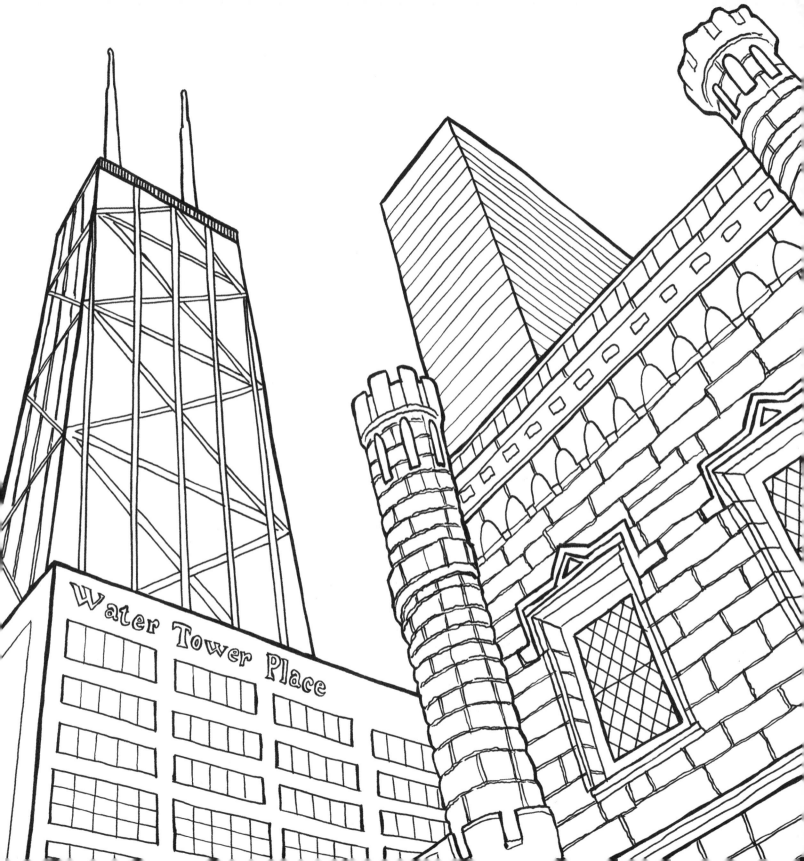

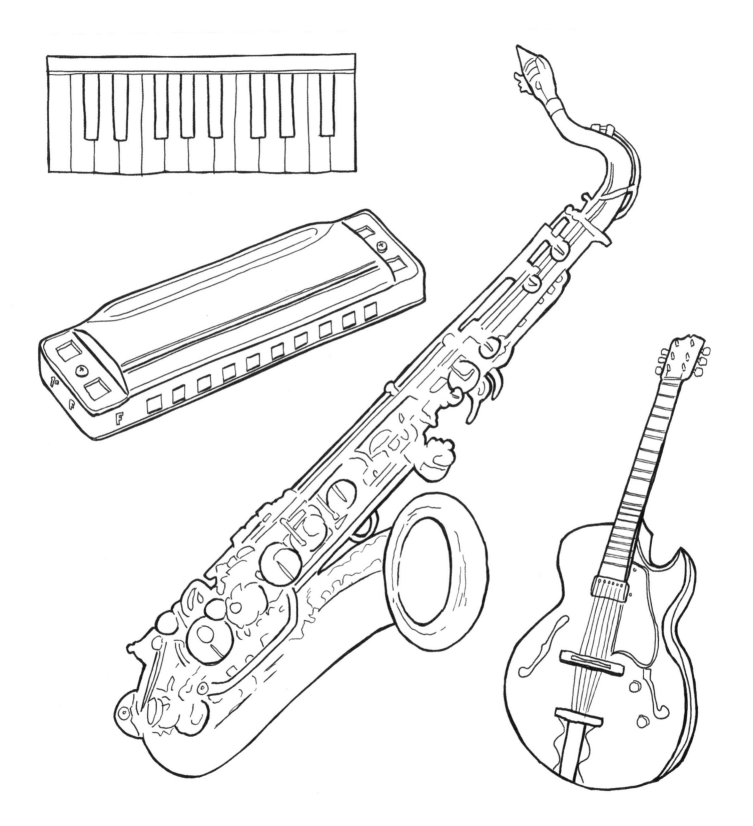

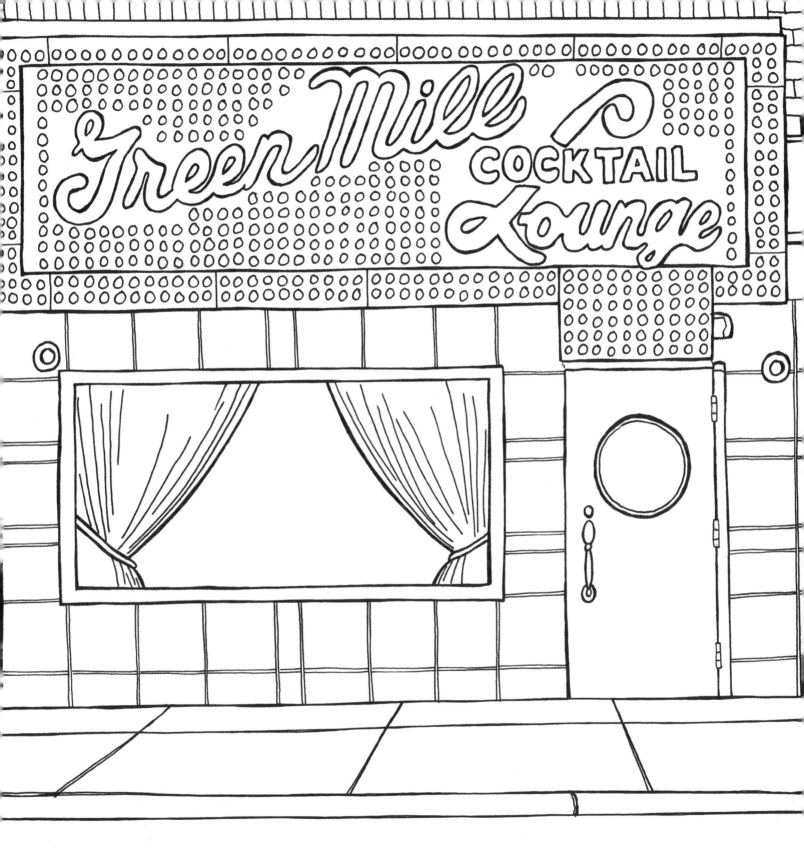

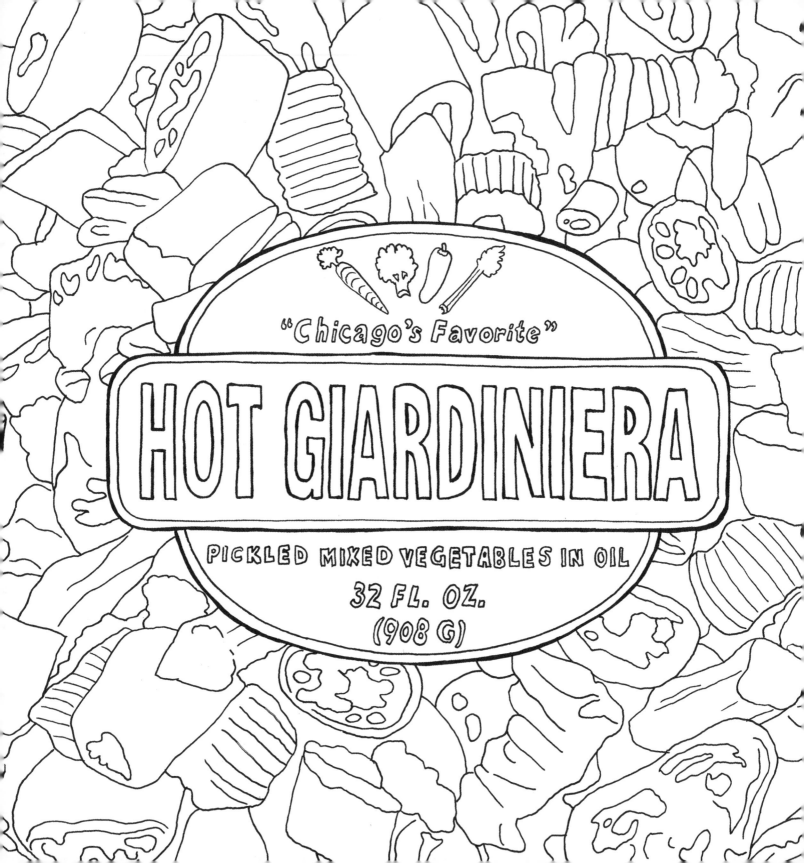

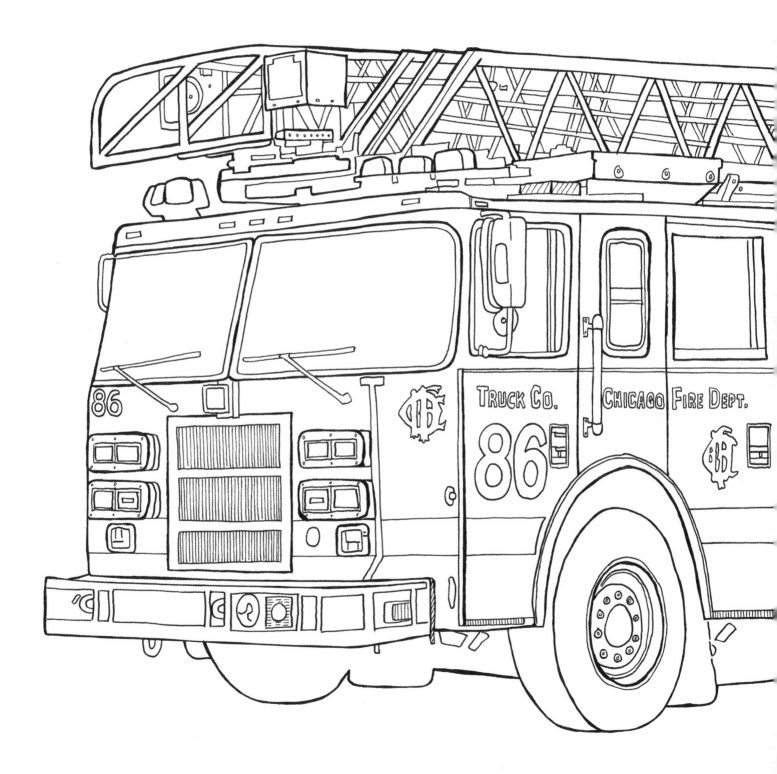

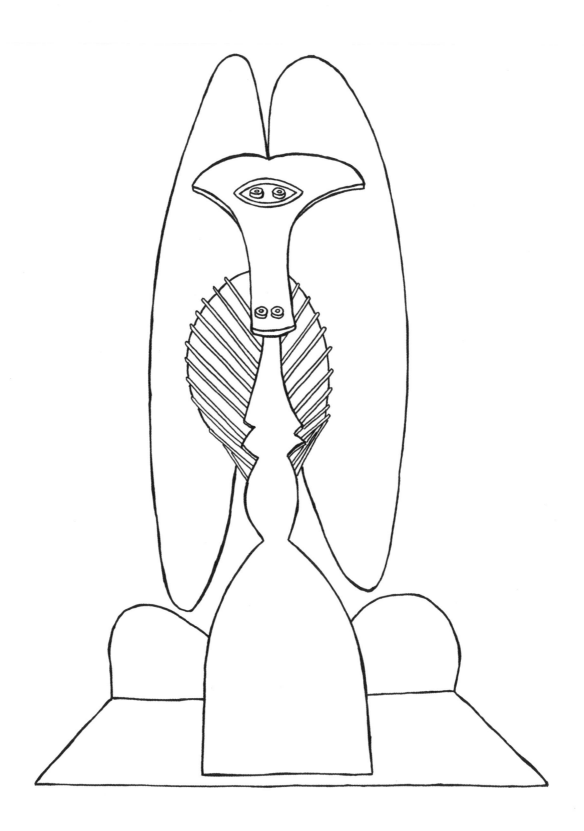

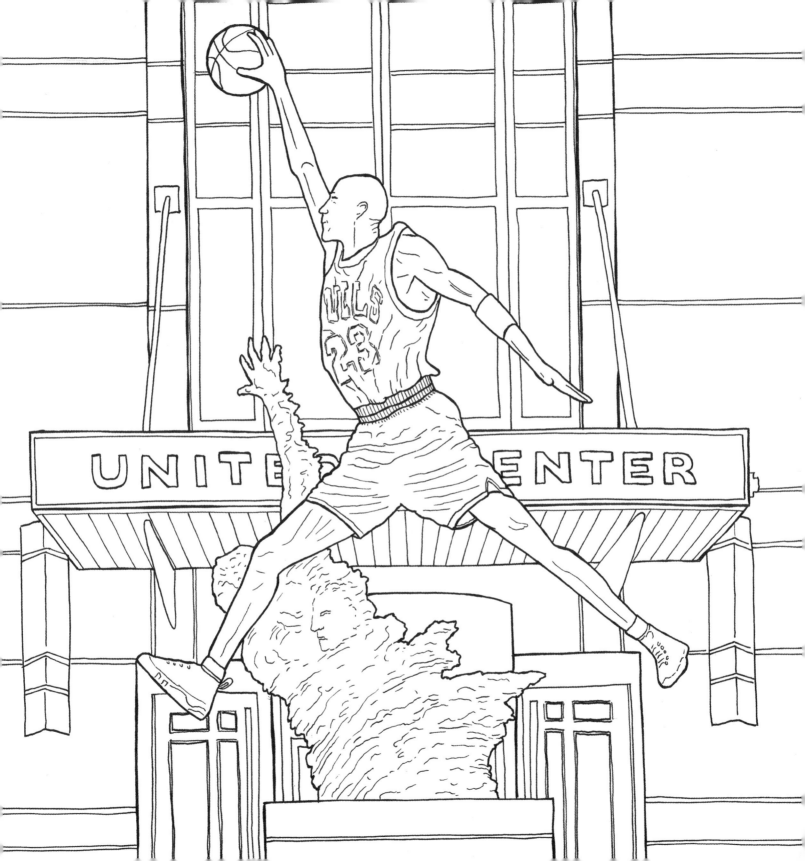

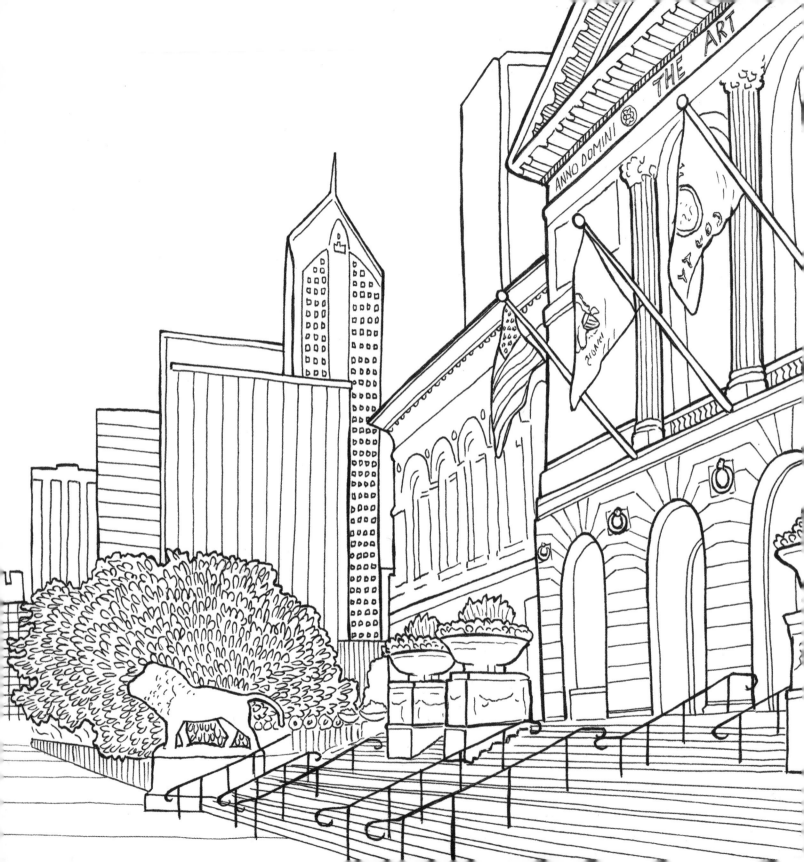

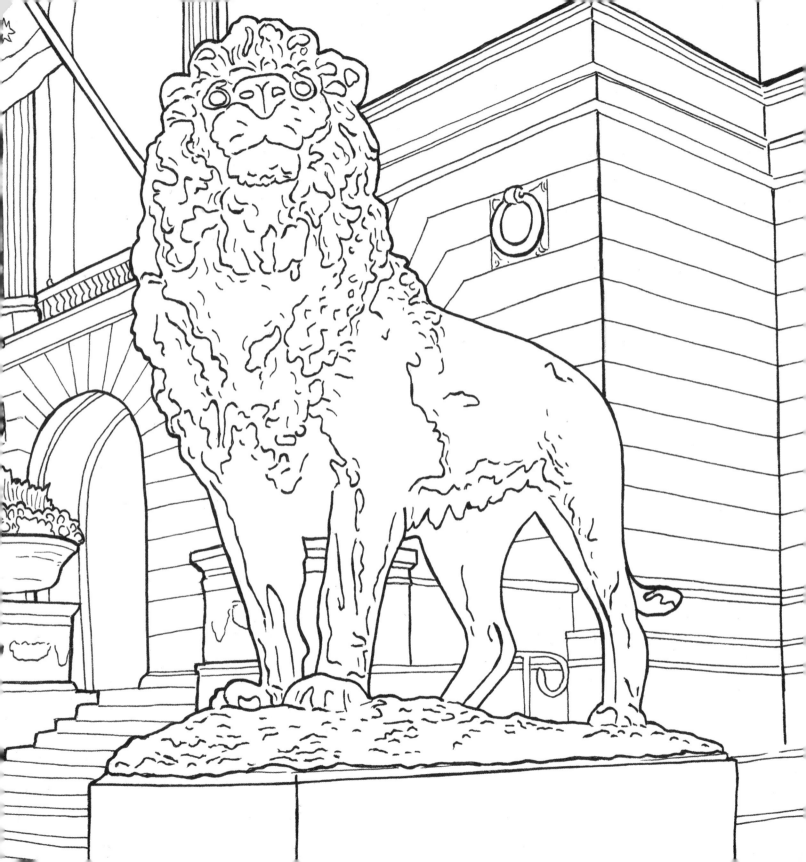

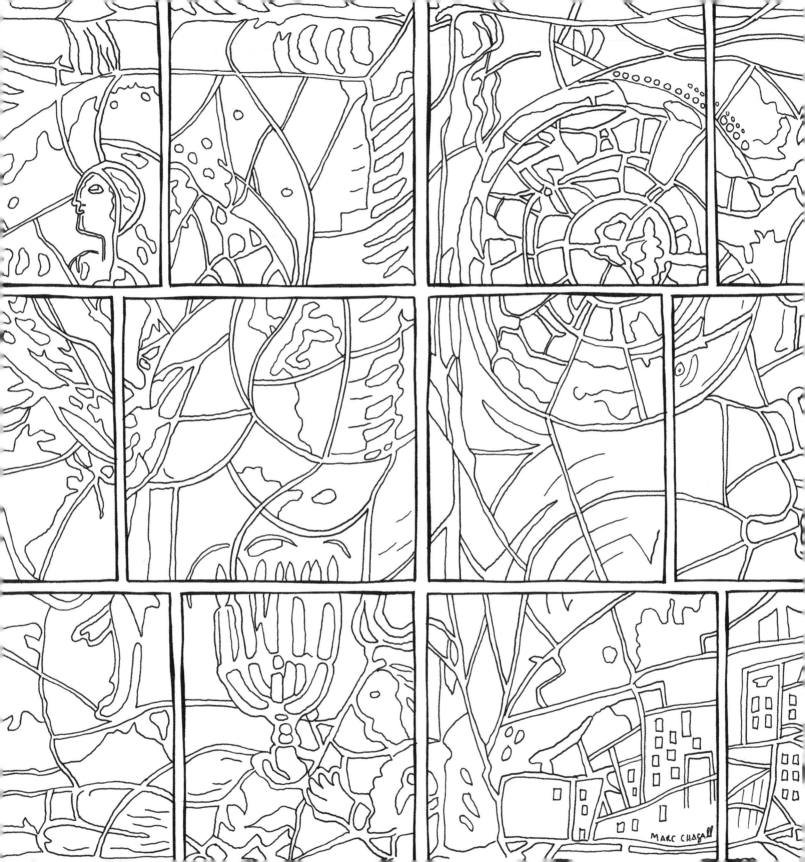

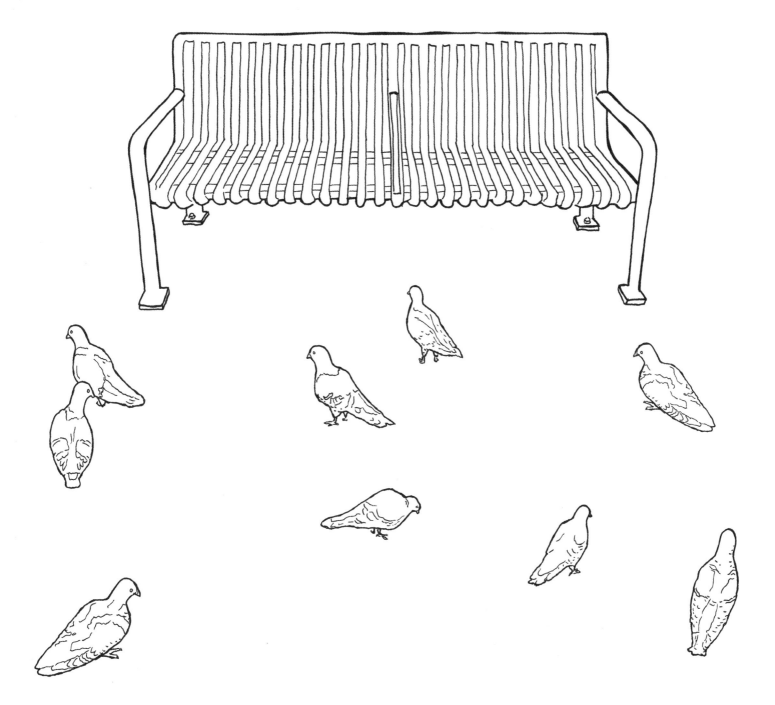

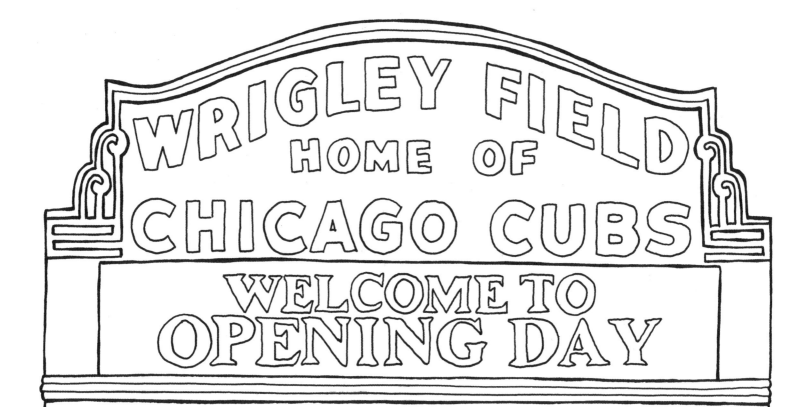

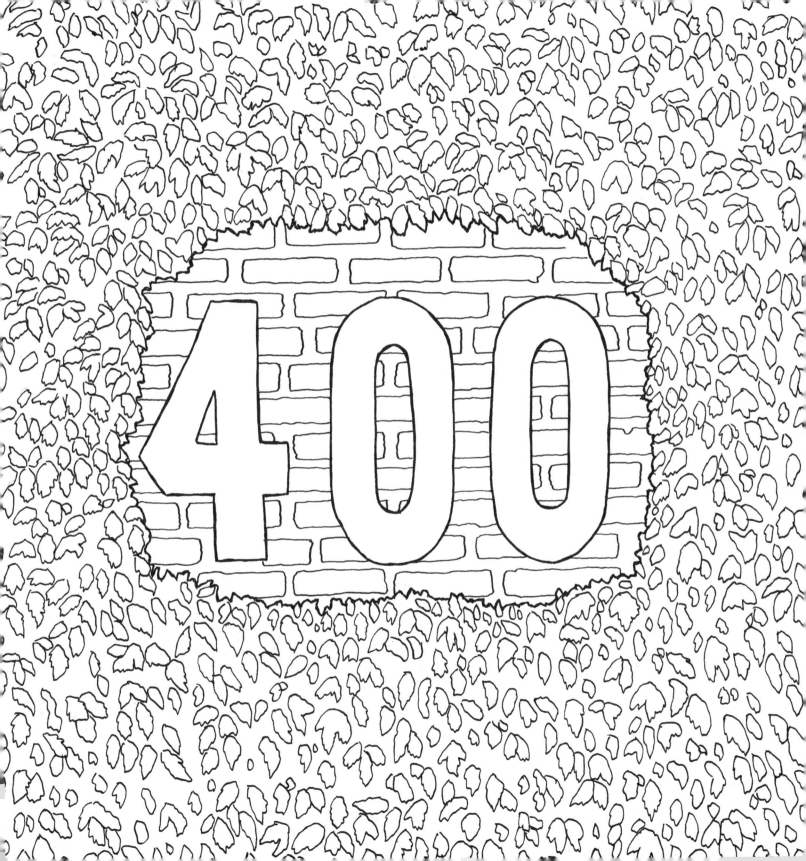

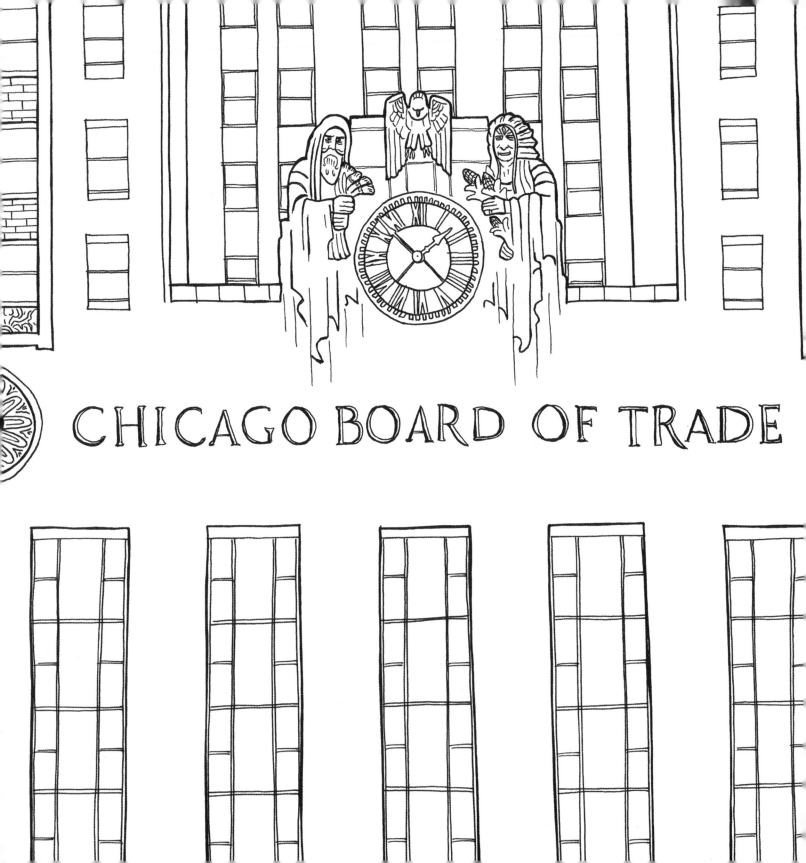

CHICAGO BOARD OF TRADE

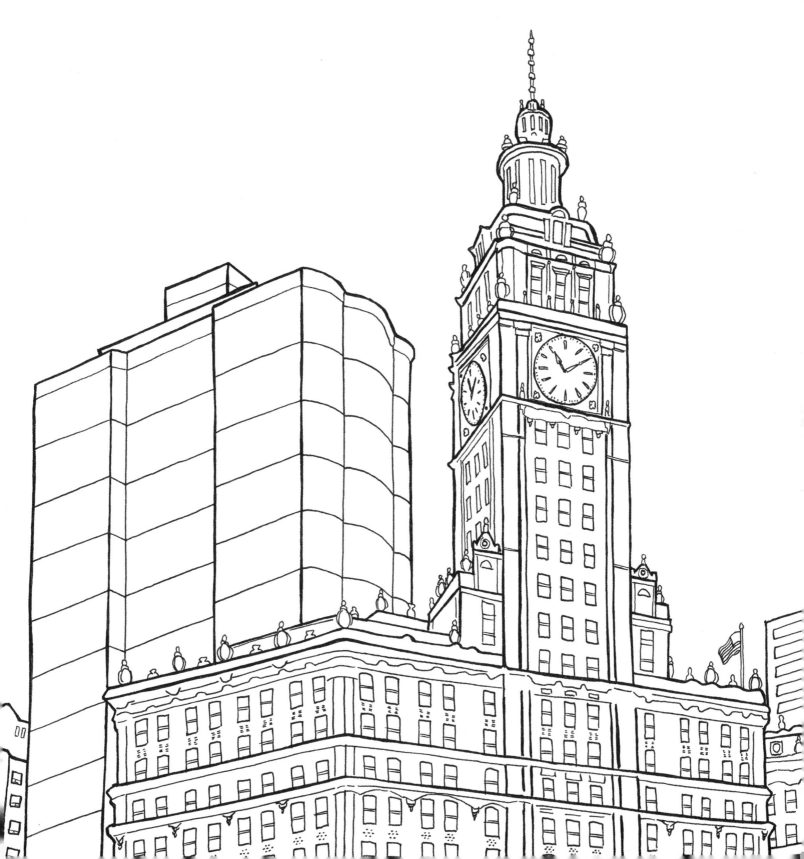

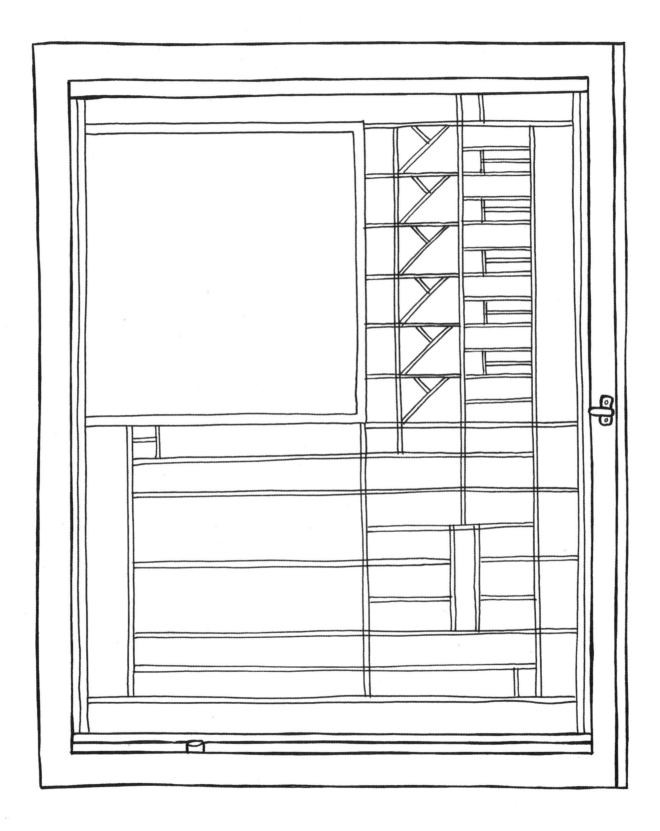

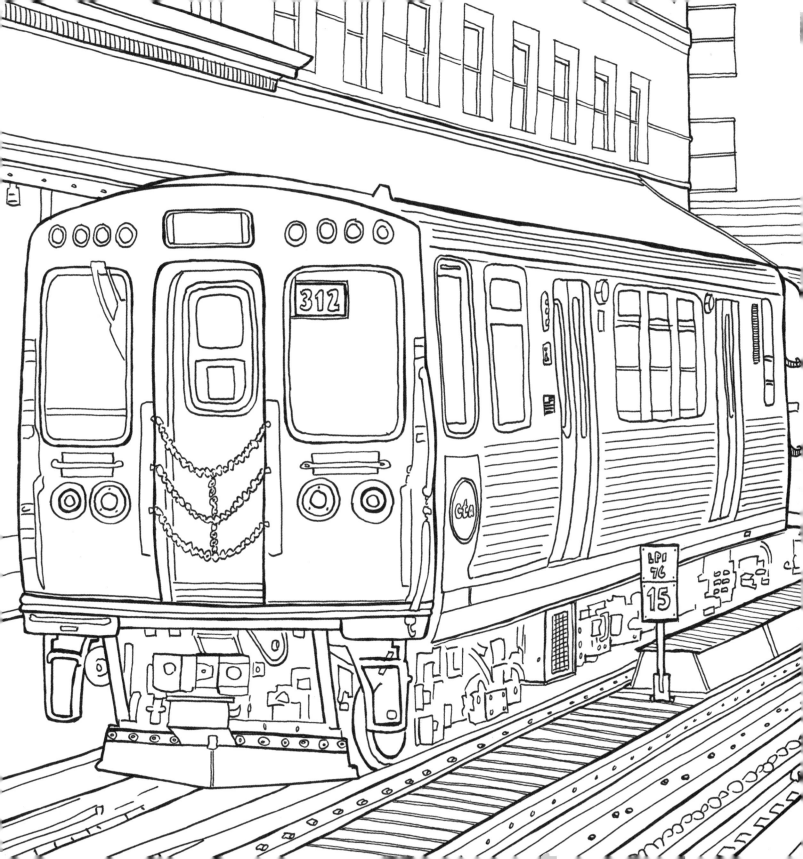

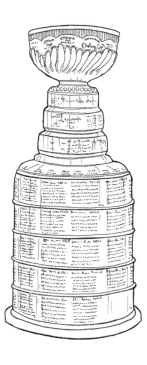

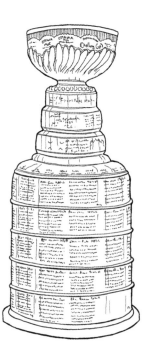

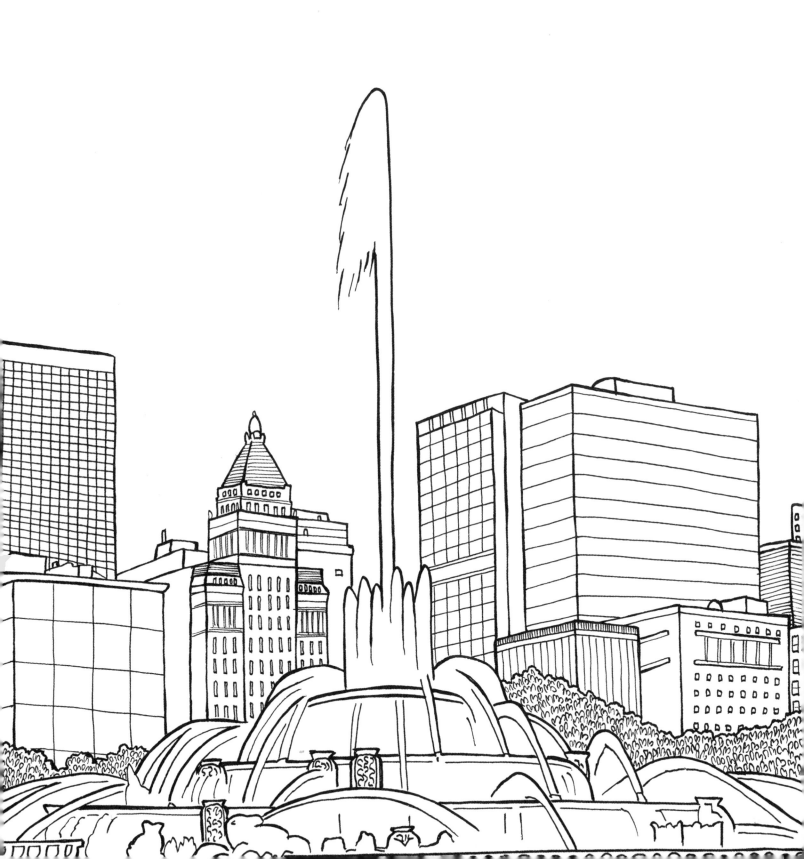

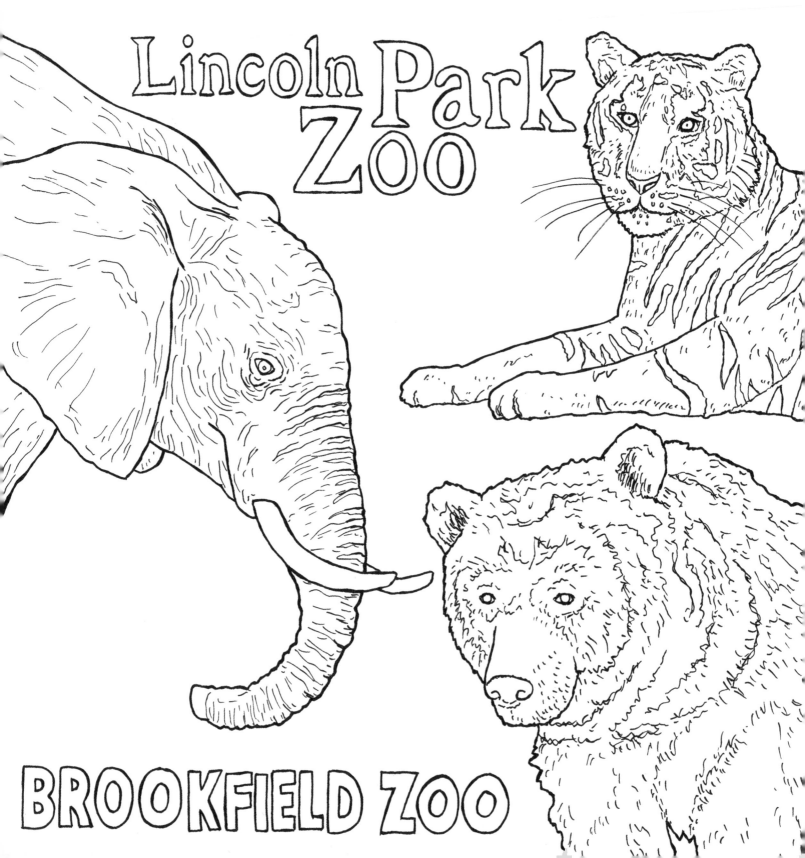

Lincoln Park Zoo

BROOKFIELD ZOO

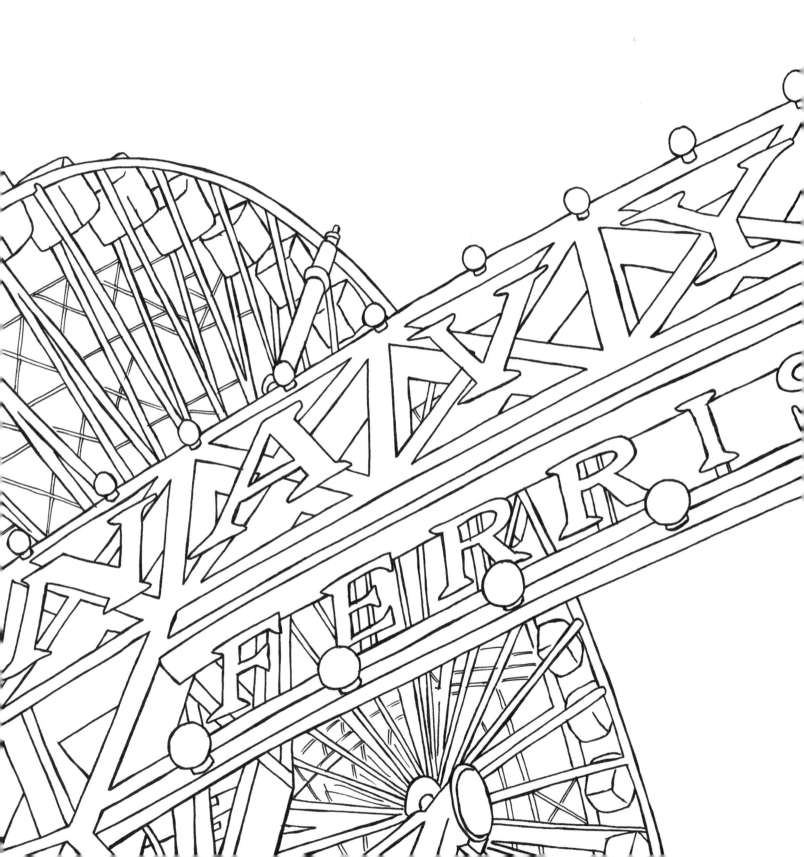

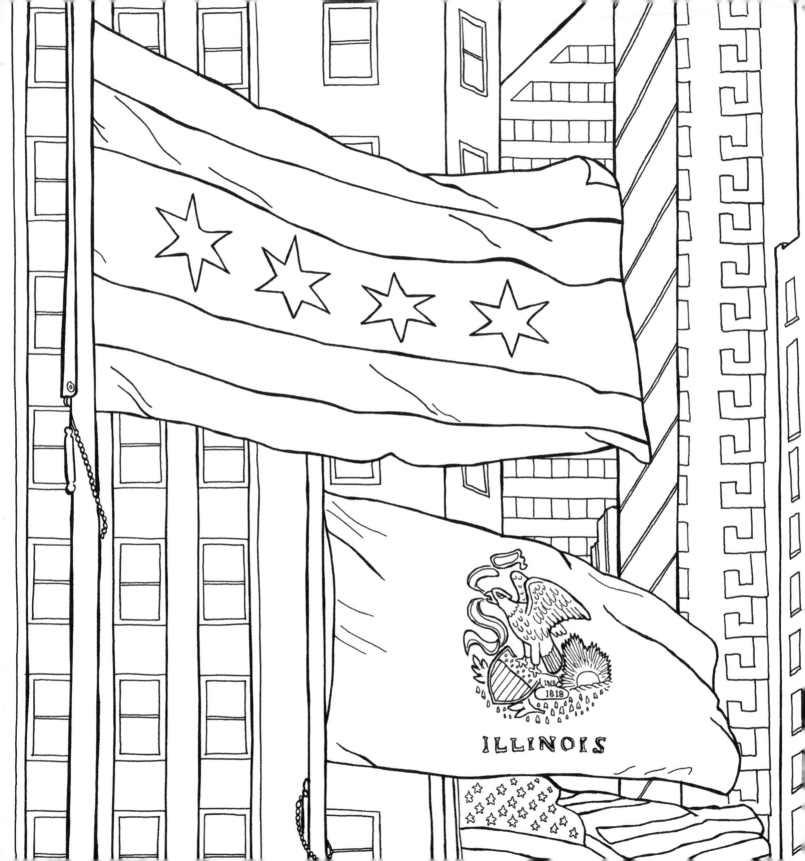

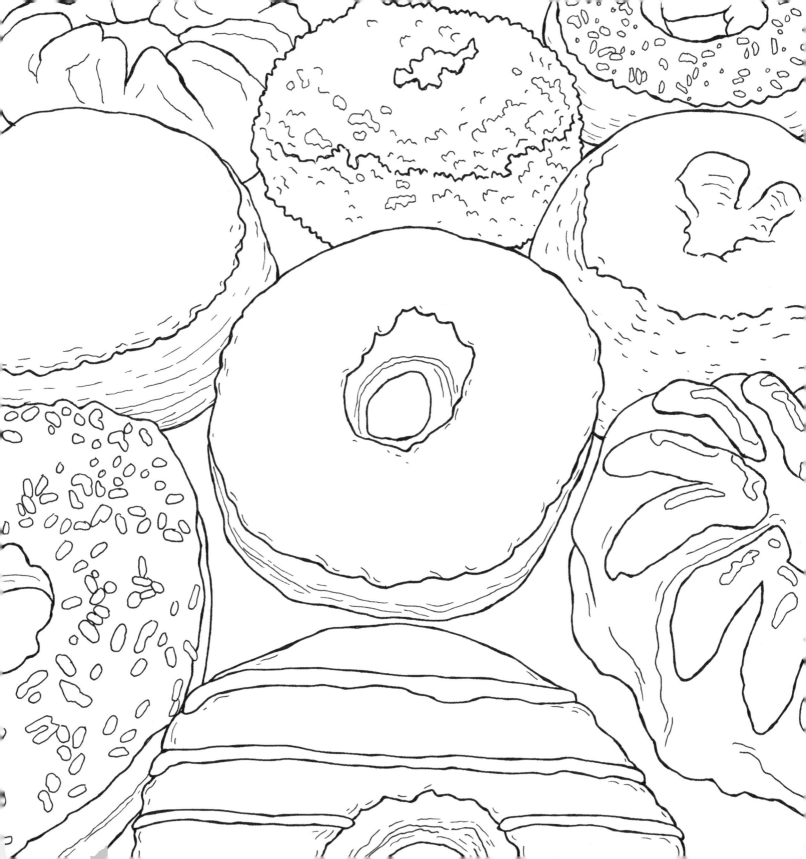

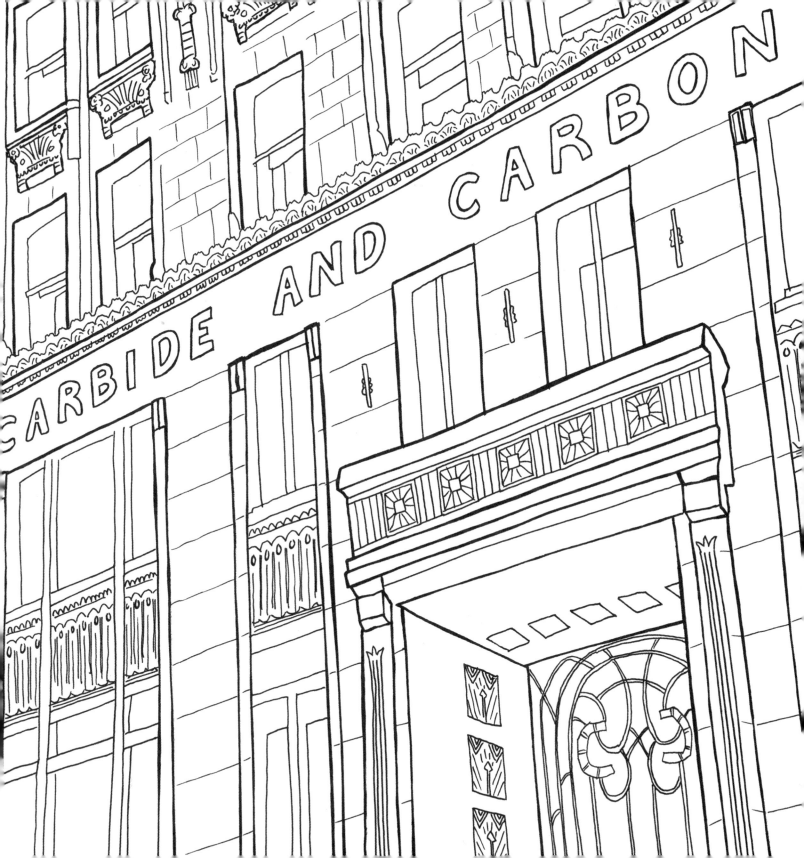

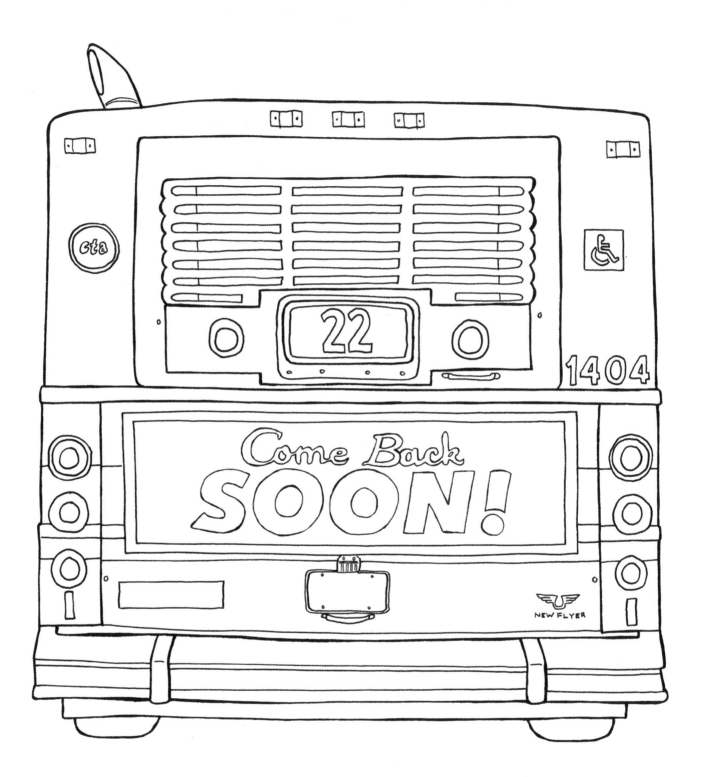

THE CHICAGO COLORING BOOK
GUIDE

Use the thumbnails below to track down illustrations, plan what to color next, and settle disputes about where exactly that cool architectural detail or funky statue can be found.

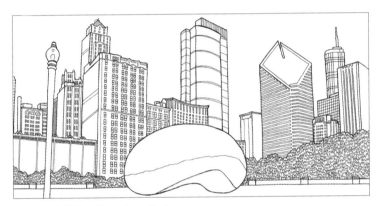

CLOUD GATE Millennium Park

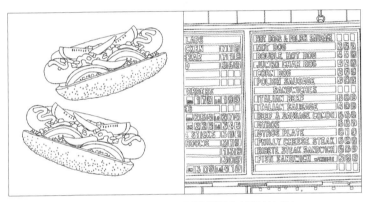

CHICAGO-STYLE HOT DOGS

MENU BOARD Wolfy's, West Rogers Park

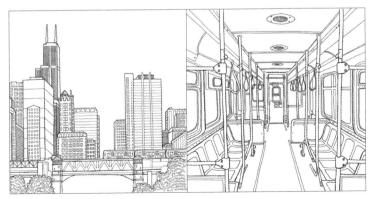

SKYSCRAPERS West Loop

EL INTERIOR Purple Line

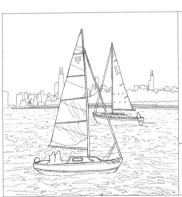

SAILBOATS Belmont Harbor

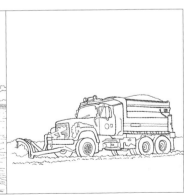

SNOW PLOW

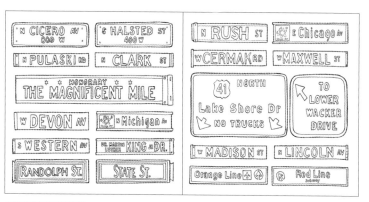

STREET SIGNS

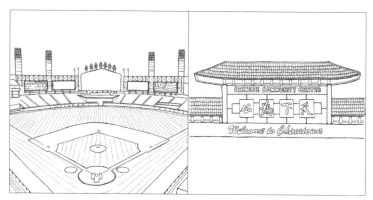

GUARANTEED RATE FIELD
Home of the White Sox

CHINATOWN GATE Chinatown

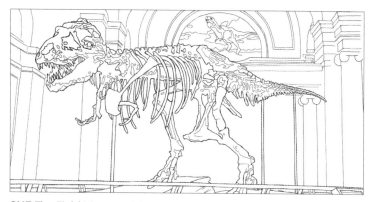

SUE The Field Museum, Museum Campus

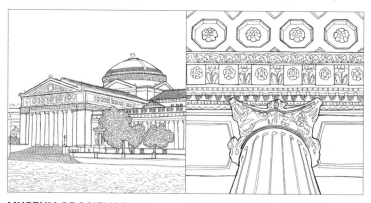

MUSEUM OF SCIENCE AND INDUSTRY Jackson Park

CHICAGO UNION STATION
West Loop

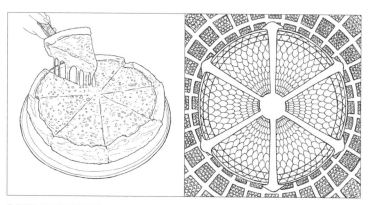

DEEP DISH PIZZA

TIFFANY DOME Chicago Cultural Center, Loop

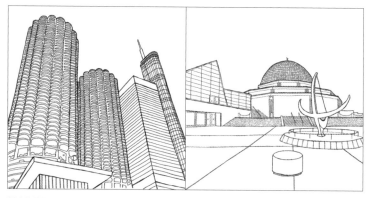

MARINA CITY River North

ADLER PLANETARIUM
Museum Campus

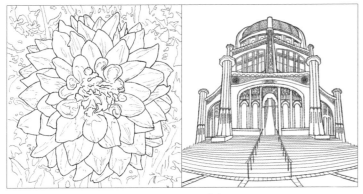

PLANT DETAIL Chicago Botanic Garden, Glencoe

BAHÁ'Í HOUSE OF WORSHIP Wilmette

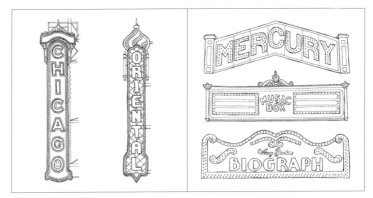

THEATER MARQUEES Chicago, Oriental, Mercury, Music Box, Biograph

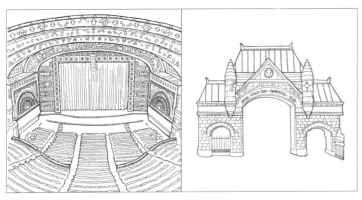

AUDITORIUM THEATRE INTERIOR Loop

UNION STOCK YARD GATE Back of the Yards

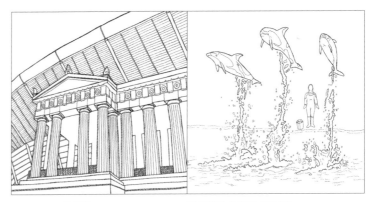

SOLDIER FIELD Museum Campus

SHEDD AQUARIUM Museum Campus

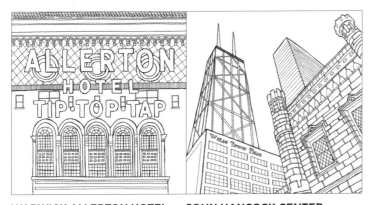

WARWICK ALLERTON HOTEL Magnificent Mile

JOHN HANCOCK CENTER Magnificent Mile

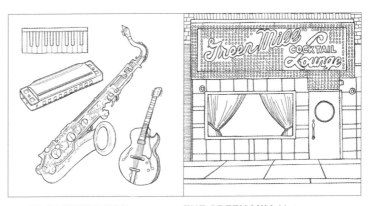

BLUES INSTRUMENTS

THE GREEN MILL Uptown

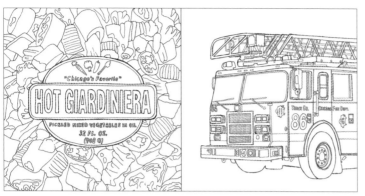

GIARDINIERA Italian beef sandwiches across the city

CHICAGO FIRE DEPARTMENT TRUCK

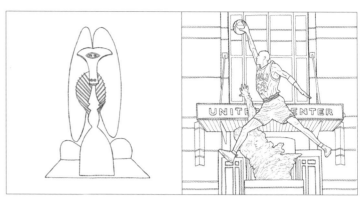

THE PICASSO Daley Plaza, Loop

THE SPIRIT United Center, home of the Bulls

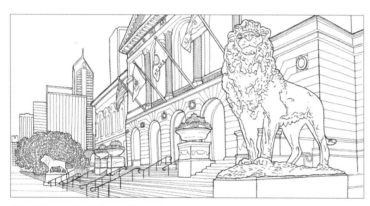

ART INSTITUTE OF CHICAGO Loop

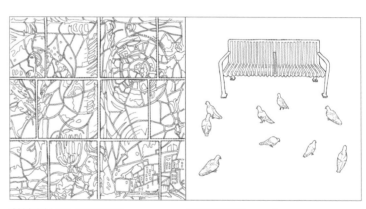

CHAGALL'S *AMERICA WINDOWS* Art Institute of Chicago

PIGEONS Everywhere

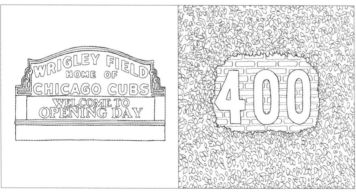

WRIGLEY FIELD MARQUEE Wrigleyville

CENTER FIELD MARKER Wrigley Field, home of the Cubs

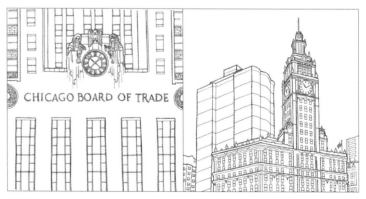

CHICAGO BOARD OF TRADE BUILDING Loop

WRIGLEY BUILDING River North

WINDOW Frank Lloyd Wright's
Emil Bach House, Rogers Park

QUINCY EL STATION Loop

STANLEY CUP × 6 Blackhawks'
championship wins

BUCKINGHAM FOUNTAIN
Grant Park

ZOO ANIMALS Lincoln Park
and Brookfield Zoos

FERRIS WHEEL Navy Pier

CHICAGO AND ILLINOIS FLAGS

GOURMET DONUTS

**UPTOWN BROADWAY
BUILDING** Uptown

**CARBIDE AND CARBON
BUILDING** Loop

ABOUT THE ILLUSTRATOR

CHRIS ARNOLD is an award-winning artist who has been featured in more than a dozen one-man exhibitions and 50 group shows both nationally and abroad. He has taught at the School of the Art Institute of Chicago (SAIC) and Illinois Institute of Art–Chicago and is currently an assistant professor at Columbia College. He lives in Chicago with his fiancée.